30-Minute Drawing for Beginners

30-MINUTE
DRAWING
for BEGINNERS

Easy Step-by-Step Lessons and Techniques
for Landscapes, Still Lifes, Figures, and More

Jordan DeWilde

Illustration by Eva Sánchez Gómez

ROCKRIDGE
PRESS

Interior and Cover Designer: Jill Lee
Art Producer: Janice Ackerman
Editor: Annie Choi
Production Editor: Ruth Sakata Corley

Illustration: © 2020 Eva Sánchez Gómez
Author Photo: Courtesy of Pixel Labs

ISBN: Print 978-1-64739-122-5 | eBook 978-1-64739-123-2

R0

I dedicate this book to my sister, Caitlin.
She encourages me whenever I have a new project.
She continues to inspire me with her strong work ethic.
I look up to her as someone who shares her passion
with others.
Thank you for being such a great big sister!

CONTENTS

LEARN HOW TO DRAW? YES, YOU CAN!

I truly believe that anyone can learn to draw if they study the basics and develop those skills with practice. As a K–12 art teacher, I have worked with students of all ages and helped them become better artists. I'm excited to help you unlock your own potential and develop new drawing skills. Drawing can be a great creative outlet to express yourself.

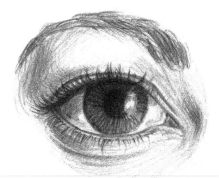

The 4 Myths About Learning to Draw

Adults fill their minds with all sorts of reasons they can't learn something new. I'm here to expose those doubts as myths and guide you on this new journey to learn how to draw. Here are some common myths about learning how to draw.

Myth 1: It's Too Hard

The most common belief I hear from people is that drawing is too hard. They believe that drawing is an innate talent that you either have or don't have. The truth is that talent comes from interest and practice. If you are not interested in an activity, then you will not be motivated to practice. Everything seems difficult when it is new to you. As you practice and become more familiar with an activity, it gets easier. You picked up this book because you have an interest in drawing. Now you just need to make time to practice.

Myth 2: I'm Too Busy

Another common myth people tell themselves is that they are too busy to learn how to draw. You have work, family, and other responsibilities and it may seem like there's little to no time for anything else. The exercises in this book are specifically developed to take no more than thirty minutes each. Try to find a small break in your day to learn some new skills. The exercises sometimes build on drawings from previous chapters, which allows you to focus on new concepts more quickly. Once you commit to thirty minutes, you may find yourself inspired to spend even more time practicing!

Myth 3: It's Too Expensive

Other drawing books and art classes can have a list of expensive art supplies. This can be intimidating for someone who is just getting started. In this book, the exercises are designed to use basic drawing materials that are relatively easy to find and inexpensive. I want you to develop your drawing skills with materials you are familiar with: pencil, paper, eraser, etc. Take a look at the list of supplies in chapter 1. You may already have some of these items at home!

Myth 4: It's Not Productive

Many adults feel guilty about picking up a new hobby. Drawing is often viewed as frivolous and impractical. However, as you begin drawing, you may find improvements in different areas of your life. Drawing allows you to express yourself creatively. When you're drawing, you have the opportunity to switch your brain off from the issues of the day and focus on line, shape, form, value, space, and texture. This can be very therapeutic. As you develop drawing skills, you're also learning how to be more observant. This can result in you achieving higher test scores and even greater productivity at work.

 With all these great benefits, there's nothing left to hold you back. Chapter 1 will go over what you need, how to carve out a comfortable space for drawing, and how to balance your new hobby with your obligations.

CHAPTER 1
Get Started

Your Drawing Kit

Before you begin, you need to assemble your own drawing kit. You may already have some of the items needed to complete the exercises in this book. Check around the house to see what you have before going to the store. These items are relatively inexpensive, but it's best to use what you are already familiar with. Once you have gathered everything you need, designate a drawer or container where you can keep your drawing kit together. This will make it easier for you to practice new techniques by having everything in one place.

Sketch Pad/Paper

When it comes to selecting paper or a sketch pad, you'll want to work on a surface that is specifically made for drawing. Choose white paper that is at least 8 x 10 inches, so that you have room to create. Touch the surface of the paper to feel for a rough texture, which is ideal.

Pencils

When you start shading your work, it helps to have specific drawing pencils. Look for a set that includes a variety of pencils labeled with H and B. The H indicates a hard pencil, and the B indicates the blackness of a pencil, or a softer lead. These can help further your range of value from light to dark. These aren't required, however. In this book, you're just getting started and can do all of the exercises with a regular number two pencil.

Erasers and Blenders

Let's face it, mistakes happen! You will need to have erasers handy to remove not only mistakes, but also guidelines and sketch marks. Any eraser will do, but a white hi-polymer eraser is preferred. Blending stumps are helpful tools when you begin shading your work, though they're not required.

Sharpening Tools

As you practice new drawing skills, you will wear down the tip of your pencil. You need a sharpened point to create your best work. Any sharpener will do, but a handheld sharpener works best. This will allow you to quickly sharpen your pencil as you work.

Optional Items

A ruler can help you create a straight line. Similarly, a compass can help you create a perfect circle. A clipboard can keep your paper still if you prefer to draw in your lap. Some exercises in this book call for a ballpoint pen; however, they can also be done in pencil. These items are not necessary, but you may find them helpful as you begin drawing.

Your Workspace

Creating a designated workspace is extremely beneficial as you begin drawing. You want to have a consistent area that has your materials ready to go when you are. Try to set up a workspace that is removed from distractions. You want your focus to be on learning new techniques. Choose a workspace that has plenty of light. You want to be able to clearly see what you are drawing. Select a comfortable chair or stool to sit on for thirty minutes. Above all, create an inviting workspace that you will be excited to go to for developing your new drawing skills!

Drawing When Life Happens

Learning to draw requires you to carve out time and space in an already busy life. While a consistent routine is ideal, sometimes life happens! You have commitments and responsibilities that may unexpectedly pull you away from your previous plans. Hobbies are often the first to go when people get busy. Be firm in your commitment to learning, but also be gentle on yourself if you need to step away. Just make sure to come back and continue your progress. Just as an athlete or musician must exercise and rehearse, you need to consistently practice developing your drawing skills.

Making Time

Take a look at your daily schedule. You have work and other commitments that are cemented in each day. Find a thirty-minute time slot where you can consistently, and realistically, commit to practicing. Put this on your calendar so that you know not to schedule any other activities during this time.

Handling Frustration

Anytime you learn something new, it is important to remember that you will not be perfect overnight. You may find some exercises more difficult than others. Know that if something doesn't look quite right, you can always retrace your steps and practice any concepts you need to improve. The point isn't to get it right the first time; the point is to learn how to see and think like an artist.

Finding Inspiration

The best drawing inspiration comes from your own personal interests. You will not be as invested in drawing a random object as you would be in drawing an object that has meaning to you. Choose objects, scenery, and people that are important to you so that you are excited to draw them!

CHAPTER 2
Sketching, Guides, and Shapes

Now that you've gathered your materials, let's start drawing! The key to improving your drawing skills is to observe your **subject**—the focus of the artwork—closely. As you start to look at figures and objects with a more discerning eye, you'll notice that almost everything is made up of a few basic **shapes**.

Identifying shapes will help you improve your sketching. **Sketching** is a quick method of drawing that serves as your rough draft, or practice. Sketching is a great way to block out basic shapes quickly, so that you can go back and add details later.

One way to begin a sketch is to create a **contour line**, or the outline of a figure or an object. Another way to improve your drawing is to practice quick sketching and gesture drawing. A **gesture drawing** records the essential pose or action of a figure.

You will practice contour line, gesture drawings, and sketching in the following exercises. Be sure to look closely at your subject and draw what you observe. Pay close attention to the shapes, lines, and space around your subject.

Exercise 1: Contour Line of Your Hand

For this first exercise, you're going to start with something that you've probably done before at some point in your life. You're going to make an outline of your hand. This may seem simple, but it's a good example of creating a contour line and will help you as you begin to develop observation and drawing skills.

DURATION: 10 minutes

GETTING STARTED: Find a flat working surface. Place your nondominant hand palm down.

Steps

1. Trace along the edges of your hand lightly with your pencil. This creates a simple contour line drawing.

2. Now place one hand down on a flat surface and draw what you observe, without tracing. Pay close attention to the proportions of each finger.

3. Add interior lines to represent your fingernails and the creases in your knuckles and joints.

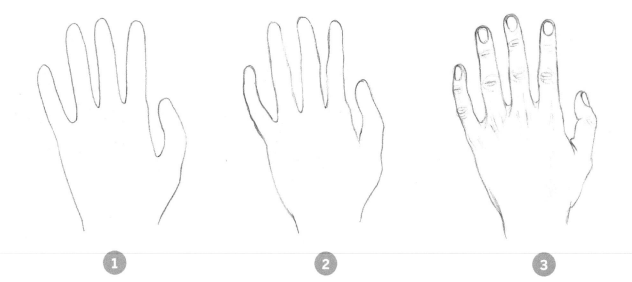

BONUS CHALLENGE

Try a contour line drawing of your hand in different positions.

Exercise 2: Contour Line of a Shoe

Using the skills you practiced in the previous exercise, we will turn our attention to the world around us. In this exercise, you'll start looking at your shoes through the eyes of an artist; that is, you will see the lines and shapes that make up the subject.

DURATION: 15 minutes

GETTING STARTED: Place a shoe on a flat surface, such as a desk or table, at about an arm's-length distance.

Steps

1. Begin by focusing on the exterior edges of your shoe. Pay attention to the shoe from end to end. **Proportion** is how each part of an object compares to one another in size. Make sure that the shoe is not too long compared to how tall you have sketched it.

2. Draw the interior edges of the shoe: the toe cap, the midsole, the tongue, etc. Don't focus on details yet. Focus on the shape of things, like the curve of the toe. Capture those things first.

3. Draw the design details of the shoe: the logo, patterns, eyelets, etc. Remember, an artist sees shape first. Think about what shapes you see and place them relative to each other.

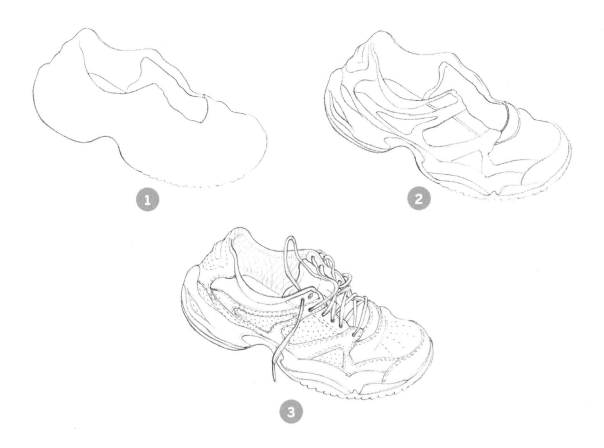

Exercise 3: Contour Line of a Chair

Now we will learn how to use guidelines to help us draw in proportion. **Guidelines** are boundaries or reference lines to help you keep your drawing symmetrical and in proportion. These don't have to be perfect, and they should not be too heavy. These are light lines that help you position what you see on a page, and you will need to erase them at the end.

DURATION: 10 minutes

GETTING STARTED: Set up a chair at about an arm's-length distance.

Steps

1. Sketch guidelines across the paper to help you draw the chair in proportion.

2. Draw the negative space inside and around the chair first. **Negative space** is the area in your drawing that does not include a subject. In this exercise, the chair is the **positive space** in your drawing. Where you can see through parts of your chair, such as between the armrest and seat, that is negative space. By focusing on the negative as well as the positive space, you can help improve your drawing technique!

3. Use the negative space drawing to help you draw the chair. Look at the areas in between, underneath, and around your chair. What shapes do you see? As you draw the negative space, or the space around your subject, your positive subject will start to appear.

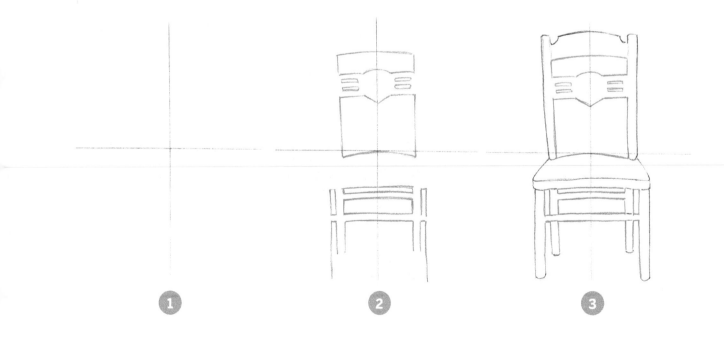

Exercise 4: Still Life

In this exercise, we will learn to draw a still life. A **still life** can be any group of inanimate objects. Artists are famous for studying a bowl of fruit, but you can arrange a collection of anything you can find. This will be timed, but don't worry too much about the clock. This is an exercise to motivate you to work quickly and show you how much sketching you can accomplish in a short amount of time.

DURATION: 15 minutes

GETTING STARTED: Set up a still life in your space, consisting of any three objects that vary in size and shape. Set a timer for two minutes.

Steps

1. Begin sketching loose marks to quickly block in basic shapes. The example shown with this step is not focused on the subject itself; it's focused on capturing the shapes that make up the subject. As always, remember to make light marks so you can erase them later as needed.

2. After two minutes have passed, see how much you were able to produce on paper. Remember, it's not about perfection. Pay attention to size and shape relationships. Does one object look too big, or out of proportion? Make corrections as needed with your eraser.

3. Practice sketches for longer durations. Set a timer for a five-minute sketch, a ten-minute sketch, and so on. By gradually allowing yourself more time, you will improve your ability to observe and draw your subject.

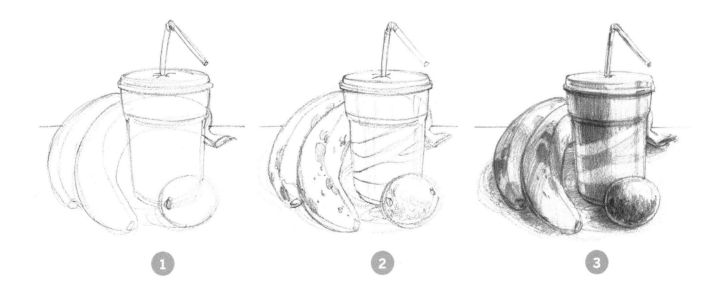

Exercise 5: Sketch a Single Object with Detail

Choose a single object to focus on in greater detail. Choose something simple, like a lamp, a coffee mug, or a bottle. The simplicity of the object's shape will make it easier for you to focus on the object's details, like patterns and symbols.

DURATION: 20 minutes

GETTING STARTED: Draw quick guidelines on your paper.

Steps

1. Sketch the shapes you see, using the guidelines for reference.

2. Make loose marks to communicate any details you notice about the subject. What patterns do you see? Does it have a label with lettering or symbols? Try to look closely and draw what you see.

3. Refine your loose sketch marks and erase the guidelines and any mistakes. Add a table or background, if you like.

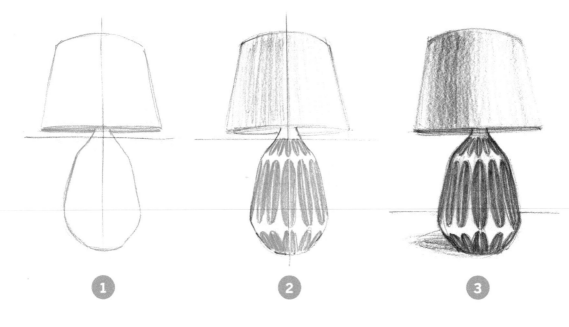

Exercise 6: Sketch a Moving Figure

A **figure** typically refers to the human body but can also refer to the shape of an animal. We use gesture drawings to demonstrate the essential pose of a figure. Imagine you are drawing athletes running around a track. They are constantly in motion, so you are not going to be able to create a detailed drawing from observation. Sketching the athlete's gesture will give you the basic information you need to complete your drawing.

DURATION: 30 minutes

GETTING STARTED: If you can't go outside to find a moving subject, try playing a video clip showing movement for reference.

Steps

1. Sketch a few shapes and guidelines to reflect the proportions and pose of your figure. You can start with a basic stick figure, but try to pose it in a motion or action stance. Imagine the stick figure running, stretching, or throwing. This will make your gesture drawing more interesting. You can take a look in the mirror at one of your own gestures or ask a friend to pose for you as well.

2. Use loose marks to sketch basic shapes to further define the body. Remember to give careful consideration to shapes. For example, one common mistake in gesture drawing is to put in a circle for the head. But look carefully—a head is not circular. It's oval. Do not obsess over fine details like fingers or facial features. This is a gesture drawing, so you just want to sketch the basic shape and movement of the figure. Artists create gesture drawings to practice observing and drawing the figure in proportion.

3. Connect the shapes by forming a darker outline to further develop the figure. You can apply more pressure with your pencil, or if you have a variety of drawing pencils, choose one with softer lead.

4. Add details like hair, facial features, and clothes to complete your sketch. Again, with a gesture drawing, you are not trying to create an exact replication, but instead provide the essential information. Give the viewer a general idea of what the figure's hair, clothing, and key facial features look like.

CONTINUED >

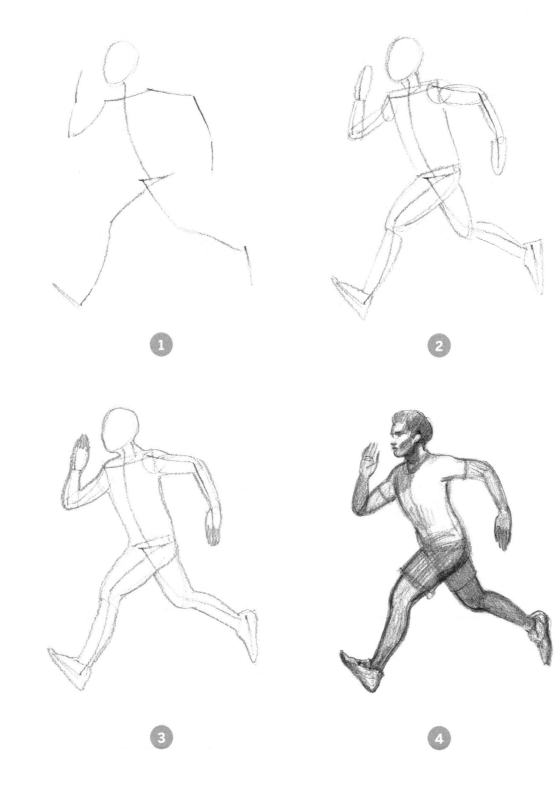

CHAPTER 3

Dimensions and Forms

In chapter 2, you practiced sketching techniques to help you become more confident in your drawing skills. Now you will experiment with adding a **range of value** to help your drawings become more three-dimensional. Value is the lightness or darkness of your subject. Highlights and shadows are examples of how you will depict a range of value in your drawing.

Three-dimensional **forms** are more lifelike than two-dimensional shapes. For example, a square is a flat, two-dimensional shape. It has height and width. In contrast, a cube is a three-dimensional form. It has height, width, and **depth**. By drawing three-dimensional forms instead of shapes, your drawings will become more realistic and less like cartoons.

Once you know how to draw a form, you can start to add value to make it look even more three-dimensional. We'll begin by using a **value scale**. On one end of the scale, you have a white square. On the opposite end of the scale, the square is completely black. In between these two extremes, you will notice the squares are gradually darker from left to right. This will be your reference when adding value to your forms.

Exercise 1: Draw a Cube

A cube is a basic three-dimensional form. It's a good idea to use a bookmark of some sort to flag this drawing in your sketchbook. We'll use this drawing in a later exercise.

DURATION: 10 minutes

GETTING STARTED: Find a ruler or other straight edge to guide you.

Steps

1. Begin by drawing a simple square.

2. Add a parallel line above the square to represent the back of the cube. Use a ruler or flat edge to create a straight line. This line will extend to the right of the square.

3. Use your ruler to draw a vertical parallel line to the right of the square to represent the side of the cube. This line can extend above the top of the square.

4. Connect these parallel lines to the square using three diagonal lines. The diagonal lines should be parallel to one another.

5. Use a darker shade for the areas of the cube that are farther from the light source. Imagine the side of your cube is getting the least amount of light. Shade it in dark gray. The top of the box is receiving the most amount of light, so leave it white. The front of the cube is receiving some light, but not as much as the top. Shade the front of the cube medium gray. We will talk more about shading and value later in this book, so don't worry if it isn't perfect.

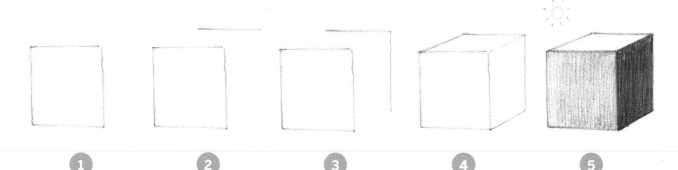

BONUS CHALLENGE

Use this form to draw a gift box. Start with the cube and add details like a wrapping paper pattern or a bow. It's also a good idea to practice drawing more cubes.

Exercise 2: Draw a Cylinder

Now let's try something curvier. You might want to flag this drawing too in your sketchbook. We'll use this drawing in a later exercise.

DURATION: 10 minutes

Steps

1. Draw two parallel lines to create the sides of a cylinder.

2. Draw an oval that fits at the top, connecting both vertical lines.

3. Draw a curved line that mimics the bottom curve of the oval at the bottom of the cylinder.

4. Shade the cylinder according to where the light is coming from.

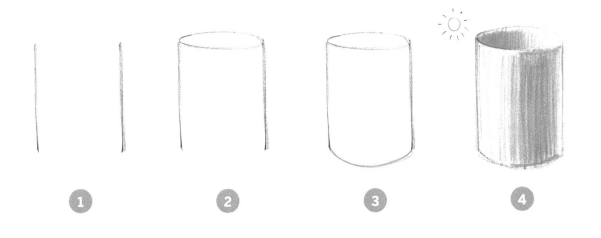

BONUS CHALLENGE

Use the cylinder to draw a soup can. It's also a good idea to draw more than one cylinder for practice, and to be able to use them in later exercises.

Exercise 3: Draw a Sphere

For this exercise, we'll learn how to draw a sphere. It's a good idea to flag this exercise and do it multiple times. Not only will it build your skills, you can come back to these sketches later, when we practice shading, hatching, and crosshatching.

DURATION: 10 minutes

Steps

1. Draw a circle. Remember to draw using light, loose lines.

2. Draw an oval underneath the circle to represent which direction a shadow would be cast.

3. Shade the sphere from light to dark as areas get farther away from the light source.

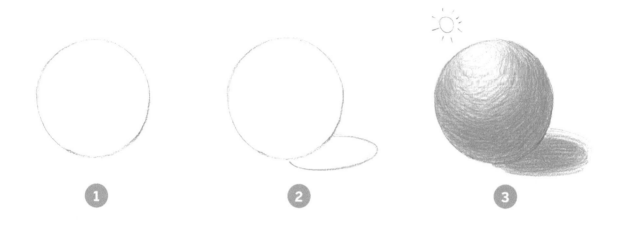

BONUS CHALLENGE

Use this form to draw a basketball. You will start with a sphere, but then add the lines on the ball. If you have a basketball or a picture to look at, you will notice that the lines follow the curve of the ball and help make your drawing look even more three-dimensional!

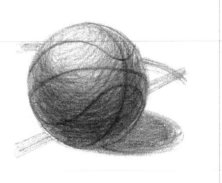

Exercise 4: Draw a Cone

With this exercise, you can improve your shape and form skills to draw an ice cream cone, if you're up for the challenge.

DURATION: 10 minutes

Steps

1. Draw two diagonal lines to create a V-shape like the sides of a triangle.

2. Draw an oval to fit inside the lines to connect the points of the two lines that are farthest away from each other.

3. Shade your cone according to where the light source is coming from.

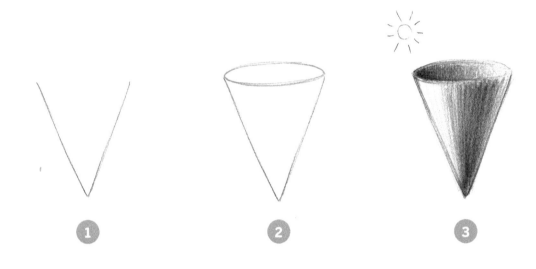

BONUS CHALLENGE

Use this form to draw an ice cream cone. Begin with your cone form, then add the checkerboard pattern of the ice cream cone by drawing intersecting diagonal lines. Create a mound or scoop of ice cream on top by using curved lines and shapes. Remember to erase any guidelines that should not be visible in the final image.

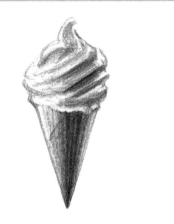

Exercise 5: Draw a Pyramid

With this exercise, you'll learn how to draw an additional three-dimensional form that dates back to ancient Egypt!

DURATION: 10 minutes

Steps

1. Draw a simple triangle using rough, loose lines.

2. Draw a diagonal line from the top of the triangle down and to the right, stopping above the bottom of the triangle.

3. Connect this line to the bottom of the triangle with another diagonal line.

4. Shade the side of your pyramid farthest from the light source. In the example on page 21, I've shaded the right side of the pyramid because the light source is at the top left corner of the page.

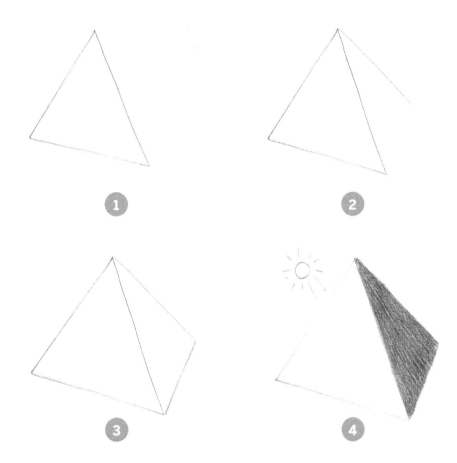

BONUS CHALLENGE

Use this form to draw an Egyptian pyramid, by drawing in lines to form bricks.

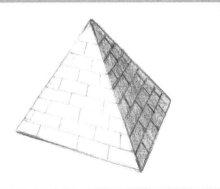

Exercise 6: Draw a Castle

Use the forms that you learned in the previous exercises to design your own castle!

DURATION: 30 minutes

Steps

1. Sketch out a cube like the one you did for exercise 1 on page 16 of this chapter. If you still have a cube from that exercise, you can build upon it for this one.

2. Create walls. The example on page 23 adds lines to create rectangles, which form bricks. You can add a shape to serve as an entry point and fill in the top to add depth.

3. Create two cylinders on the side of your castle, using what you learned in exercise 2 on page 17. Draw slightly rounded horizontal lines when adding bricks on the towers.

4. Create a roof using the cone or pyramid. Refer to exercises 4 and 5 (see pages 19 and 20) if you need a refresher.

5. Add decorative spheres. Refer to exercise 3 (on page 18) if you need a refresher.

6. Imagine where the light is shining on your castle and add value by shading each form. If you're feeling adventurous, try adding a landscape to the sketch.

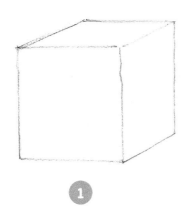

1

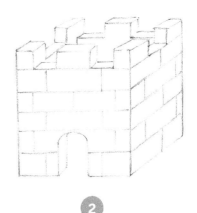

2

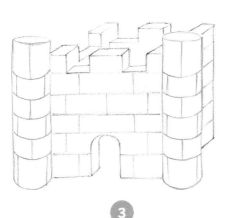

3

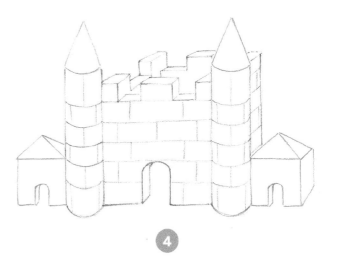

4

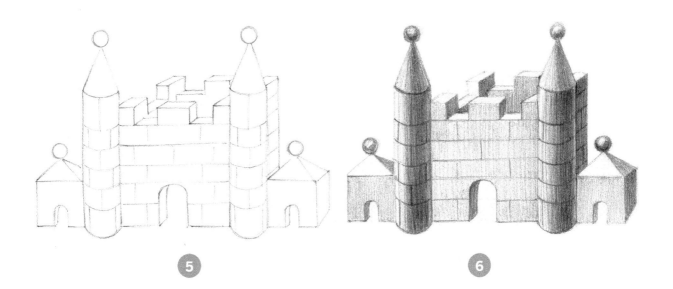

5

6

CHAPTER 4
Proportions, Space, and Composition

Now that you have a strong understanding of dimensions and form, you are ready to take your drawings to the next level. Pay attention to proportions when drawing your subject. **Proportion** is the size relationship of individual parts compared to the whole.

Once you practice getting proportions right, you'll see how the drawing comes to life. However, drawings are more than just a single subject. You need to ground your subject in space. This can be on a table, in a room, outside on the grass, etc., so that your objects don't seem to float in the middle of the paper.

As you're sketching the subject and its environment, you'll want to plan the overall composition. **Composition** refers to how the various elements of the drawing relate to one another in the space. Generally, you want to fill the page and not leave a lot of empty space. You can achieve strong composition by balancing the elements in your drawing symmetrically or asymmetrically. *Symmetrical balance* is achieved by arranging the elements in your drawing equally on both sides of the center of the paper. *Asymmetrical balance* is achieved by arranging the elements differently on either side of the center.

Exercise 1: Create an Illusion of Space

In this exercise, you will be creating the illusion of space by drawing overlapping objects. While the objects are actually the same size, when you look at them at varying distances, they appear smaller. Use this exercise to help you practice the illusion of space.

DURATION: 10 minutes

GETTING STARTED: Set up three items that are exactly the same in size and shape. Arrange them progressively farther away from you and with space in between. For this example, I'm using mugs.

Steps

1. Draw the object that is closest to you large and low on the paper. Remember to think about the fundamentals we covered in the previous chapters. Focus on sketching the shapes you see rather than trying to copy what's in front of you. In this example, the sketch captures a cylindrical shape with an oval at the top and curved lines to show depth and dimension. Together, these components make a mug.

2. Draw the second object as shown in the sketch on page 27. Notice that as the objects get farther away, you will draw them smaller and higher on the paper.

3. Draw the third object even smaller and higher on the paper.

4. Try adding more detail to your drawing.

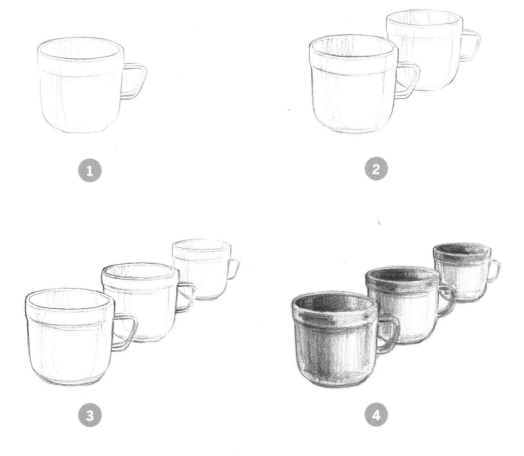

Try to draw a similar arrangement of objects that are different in size and shape, but still achieve an illusion of space.

Exercise 2: Draw a Landscape

Just as you created the illusion of space in the previous exercise, you can apply the same process to creating a landscape. Objects in the **background** are going to be farthest from the viewer and appear small. Objects in the **foreground** are going to be closest to the viewer and appear large. Objects in the **middle ground** will appear to be somewhere in between, both in space and in size.

DURATION: 15 minutes

GETTING STARTED: Rotate your paper or sketchbook so that it is horizontal.

Steps

1. Draw a jagged line to represent a mountain range. The mountains will serve as the background, so it's best to set the line toward the top of the page.

2. Draw a wavy line to represent hills underneath the jagged lines. This will be the middle ground, so it's best to set it in the center of the page.

3. Draw a straight line to represent the grass close to the bottom of the page. It does not have to be perfectly straight. This will be the foreground.

4. Draw a large tree in the foreground and a small tree in the middle ground. Remember not to think of these as trees, but as shapes and lines that come together to form trees.

5. Feel free to have fun with your sketch. Add more trees, if you'd like. Add some grass or anything else that brings the image to life for you.

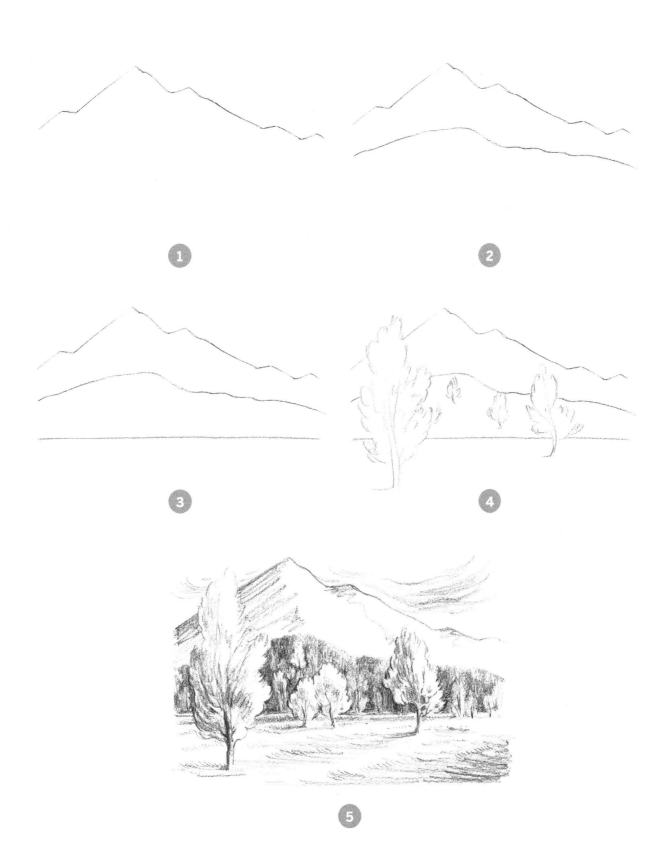

Exercise 3: Draw a Portrait in Proportion

Drawing portraits can be intimidating for beginners. However, by learning how to correctly draw in proportion, portraits will become easier as you practice.

You will use this sketch again later in the book. Be sure to mark this page with a sticky note to refer back to it later.

DURATION: 20 minutes

Steps

1. Begin by sketching out the rough shape of a head and neck. As always, think about shape. You may be tempted to draw a circle sitting on top of a rectangle, but remember that a head is actually oval, and a neck isn't exactly rectangular.

2. Draw a few guidelines that will help you put facial features in the correct position. Start with a line down the middle of the head shape. This will help you make sure that features are symmetrical. Draw a line halfway across the middle of the head. This will be where you draw the eyes. Halfway in between the eye line and the chin, draw another line across the head shape. This will be where the nose rests. Halfway between the nose line and the chin, draw a final guideline across the head shape. This will be where the lips meet.

3. Draw the eyes along the middle guideline and sketch out eyebrows above them. Remember to think about the shape and lines. Add rounded shoulders coming out from the neck and trailing off the page.

4. Draw the nose resting on the next guideline. The bridge of the nose begins at the eyebrows and comes down with two curved lines facing inward. The tip of the nose is a circular shape. Draw the sides of the nose by creating two curved lines facing outward and ending at the bottom. Draw in oval nostrils to complete the nose. Look in the mirror to identify shapes and curves you see on your nose. Remember, if you make a mistake, it's okay to erase and try again.

5. Draw the lips meeting on the third guideline. Draw the top lip like two hills with a valley in the middle. Draw the bottom lip as a downward curve and slightly bigger than the top lip.

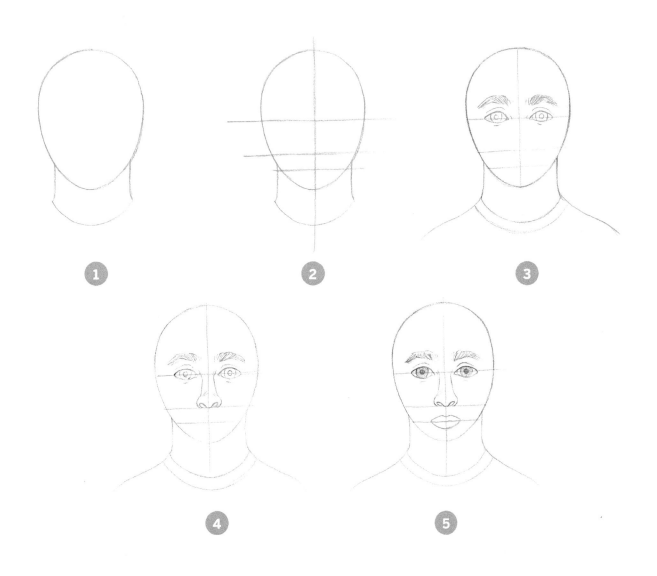

BONUS CHALLENGE

Add unique characteristics to your portrait. Try sketching details like different hairstyles, facial hair, dramatic makeup, etc. You can refer to photographs or magazine images for inspiration. Use your observation skills to identify basic shapes and forms and sketch these characteristics on your portrait. Draw a few generic faces, which we will use in another chapter.

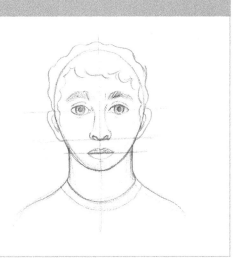

Exercise 4: The Human Figure in Proportion

The average adult human body is about seven heads tall, so we will use seven ovals of roughly the same size stacked on top of each other to study proportion.

DURATION: 30 minutes

Steps

1. Lightly draw a stack of seven identical ovals for reference. Draw a guideline halfway through the stack of ovals. This guideline will be the waist.

2. Draw the arms relaxed with the hands just below the waist. Think of your traditional stick figure, but imagine where the joints would be. Look at your own arm and see how it doesn't rest as one straight line, but instead is jointed at the elbow. Use two straight lines to represent each arm and oval shapes to draw in the hands. You should not be focused on drawing realistically just yet. First you need to master the proportions and lay a foundation.

3. Draw the legs and feet similar to how you drew the arms and hands in step 2. Think about how the legs will be posed and where they will connect to the pelvis. The pelvis can be sketched as a rectangular shape below the torso. As you are drawing the legs, think about where the knee might be bent. Use oval shapes to represent the feet.

4. Using basic ovals and squares, give form to the figure. The torso can be composed of rectangles and squares. The arms gain form when you draw in some ovals, similar to the shape of paper clips. Elevate the stick figure to a figure with more shape.

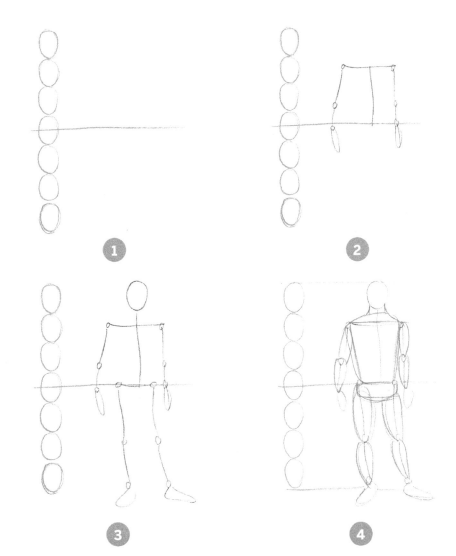

1

2

3

4

Design clothing for your figure.

Exercise 5: Symmetrical Composition with Abstract Shapes

For this exercise, you're going to use abstract shapes to create a design, rather than drawing from observation. Creating a design using abstract shapes and lines will help you better understand the concept of **symmetry**. This develops your skills in drawing balanced compositions.

DURATION: 15 minutes

Steps

1. Draw a single shape in the center of the paper. For this example, I am using a triangle.

2. Draw two identical shapes on either side of the center. These shapes should be different from your first shape. For this example, I am using two circles.

3. Continue adding identical shapes to fill your composition. Each time you add a shape on one side of the center, you need to duplicate it on the other.

4. Use the same process of repetition by adding different lines to your composition. Try straight, wavy, or zigzag lines to make your design more interesting.

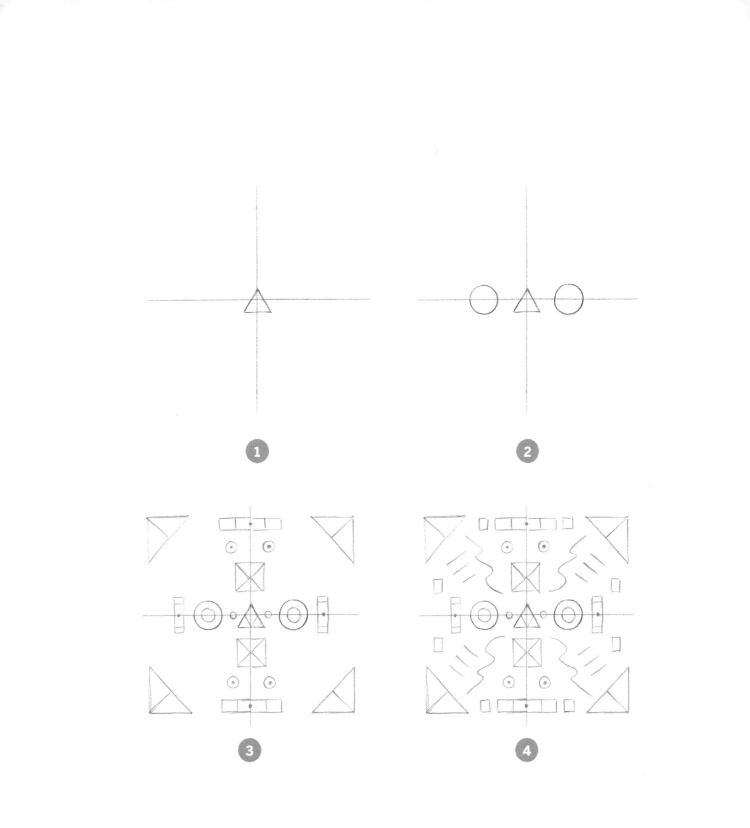

Exercise 6: An Asymmetrical Still Life

In chapter 2, we sketched our first still life, but we did not talk about its composition. In this exercise, we'll think about more than just our subject. We will think about **asymmetry**, composing a sketch, and giving the sketch a background.

DURATION: 30 minutes

GETTING STARTED: Choose one tall or large object, and two smaller ones. For this example, I am using a container of orange juice, jam, and peanut butter. You can use any such items you have around. Arrange them in a way that creates asymmetrical balance, meaning they don't line up perfectly.

Steps

1. Draw the large object to fill the space almost reaching the top and bottom edges of the paper. Remember that you're trying to capture the shapes that make up the container, not the container itself. Also remember to focus on the lines, not details like the label.

2. Draw the two smaller objects in proportion to your large object. Fill the empty space so that your subject matter reaches near each edge of the paper. As you sketch in the basic shapes, you can begin to add details like labels, patterns, etc., to your objects.

3. Draw an environment around your objects to complete your composition. In my drawing, I added a horizontal line to indicate a countertop and a window. On yours, this can be anything you like!

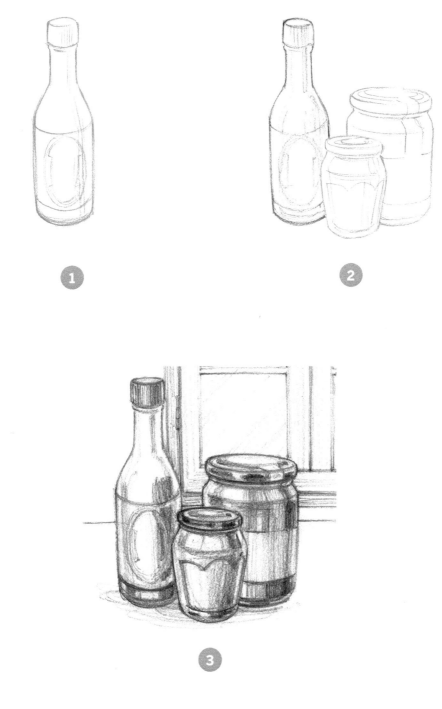

CHAPTER 5

Perspective and Angles

Your drawing skills are becoming more and more realistic because of your attention to proportions and how you fill the space of your composition. So far, you've been approaching each exercise from a singular vantage point. **Perspective** refers to how your three-dimensional forms appear on a two-dimensional surface. Paper is flat, but by using perspective, you can create the illusion of depth by drawing three-dimensional forms.

By using different angles in your drawing, you can define different points of view. If you look at a building straight on, it's going to look very different from how it would if you were to look at it from the side or from above. Angles help the viewer understand where the subject fits into space.

Perspective is not just what we see, but how objects recede from our view and become smaller as they reach the vanishing point. The **vanishing point** is where receding parallel lines are so far away that they seem to converge. You encountered this in chapter 4 when you created a landscape with foreground, middle ground, and background. Each tree was a different size in relation to how near or far it was from the viewer. This is called **atmospheric perspective**. In this chapter, you will practice other uses of perspective and angles to create new three-dimensional drawings.

Exercise 1: One-Point Perspective

For this exercise, we'll create a **one-point perspective** drawing, which has only one vanishing point. We'll start with a **horizon line**, a line that designates where the sky meets the ground. The vanishing point will be grounded on this line, and everything else will be drawn based on this. Everything in your drawing will grow increasingly smaller until it disappears at the vanishing point.

DURATION: 10 minutes

GETTING STARTED: Find a ruler or straight edge to guide you.

Steps

1. Use a ruler to create a straight line across the paper. This is the horizon line. Draw a very small dot on the middle of the horizon line. This is the **vanishing point**.

2. Use a ruler to draw a diagonal line from the bottom left side of the paper to the vanishing point. Draw another diagonal line to the vanishing point from the bottom right side of the paper. These lines will represent the edges of a road. Notice how the road is wide at the bottom of the paper and becomes increasingly smaller until it disappears at the vanishing point.

3. Add details like lines going down the center of the road. These can include sidewalks on both sides and clouds in the sky, if you wish.

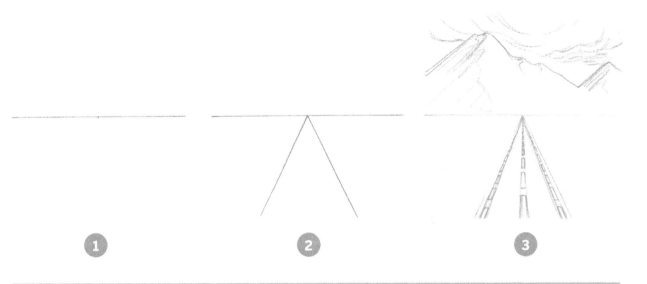

1 2 3

BONUS CHALLENGE

Add electricity poles on both sides of the road that gradually get smaller as they reach the vanishing point. If you're enjoying this activity, feel free to make it your own. Combine concepts from other chapters to practice your new skills.

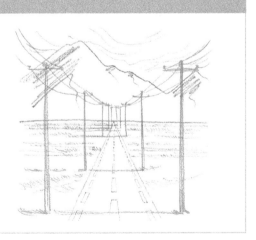

Exercise 2: Two-Point Perspective

Now we'll create a **two-point perspective** drawing using two different vanishing points. For this exercise, remember to draw lightly, since you will need to erase many guidelines. You can darken the lines you'd like to keep as a final step.

DURATION: 15 minutes

GETTING STARTED: Find a ruler or straight edge to guide you.

Steps

1. Begin by drawing a horizon line across the paper. With this exercise, you will have two vanishing points. Draw one vanishing point toward each end of the horizon line.

2. Draw a vertical line on the horizon line near the center of the page. Draw two shorter vertical lines on either side of the first vertical line.

3. Angle your ruler to connect the vertical lines with diagonal lines to the vanishing point on either side. This forms two sides of a cube on the horizon lines.

4. Erase any extra guidelines. In this case, these are the lines connecting the points on the shorter vertical lines and the endpoints on the horizontal line. On the same paper, draw three vertical lines above the horizon, near the upper left corner of the page. The center line should be higher than the other two. The line to the left should be closer to the center line than the line on the right.

5. Angle your ruler to connect the vertical lines with diagonal lines to the vanishing point on either side. This forms two sides of a cube above the horizon line. Now we need to draw where we can see the bottom of the cube.

6. Angle your ruler to the opposite vanishing point to draw diagonal lines to form the bottom of the cube. This creates a cube from a perspective that is above the horizon.

7. On the same paper, draw three vertical lines below the horizon. The center line should be lower than the other two. The line to the right should be the shortest, sitting higher on the page than the other two. It should also be slightly farther from the center line than the line on the left.

8. Angle your ruler to connect the vertical lines with diagonal lines to the vanishing point on either side. This forms two sides of a cube below the horizon line. Now we will draw where we can see the top of the cube.

9. Angle your ruler to the opposite vanishing point to draw diagonal lines to form the top of the cube. This creates a cube from a perspective that is below the horizon line. Erase any guidelines and complete your drawing.

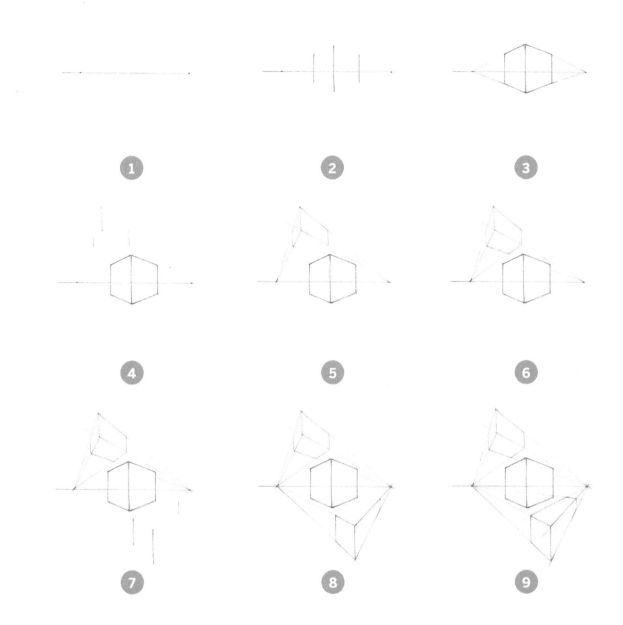

Use your imagination and enjoy yourself by turning this sketch into any drawing you'd like. You can turn these cubes into drawings of gift boxes, for example, and draw a background if you like.

Exercise 3: Draw Your Living Room in One-Point Perspective

For this exercise, remember to draw lightly, since you will need to erase many guidelines. You can darken the lines you'd like to keep as a final step.

DURATION: 30 minutes

GETTING STARTED: Find a ruler or straight edge to guide you.

Steps

1. Begin by drawing a rectangle in the center of the paper. This will represent the back wall in your drawing. Draw a small vanishing point in the middle of the square.

2. Angle your ruler to connect the vanishing point to each corner of the square. Extend a line from each corner to the edges of the paper. This will form the ceiling, two walls, and floor in the drawing.

3. Everything you decide to add to your room needs to angle back to the vanishing point in order to look realistic in the space. Start by adding a window. Draw two vertical lines on the right side of the walls. The line closest to the edge of the page should be slightly longer.

4. Angle your ruler to connect the lines at the top and bottom to create a window that recedes into space, toward the vanishing point. Darken the lines that form the window and erase the lines that do not.

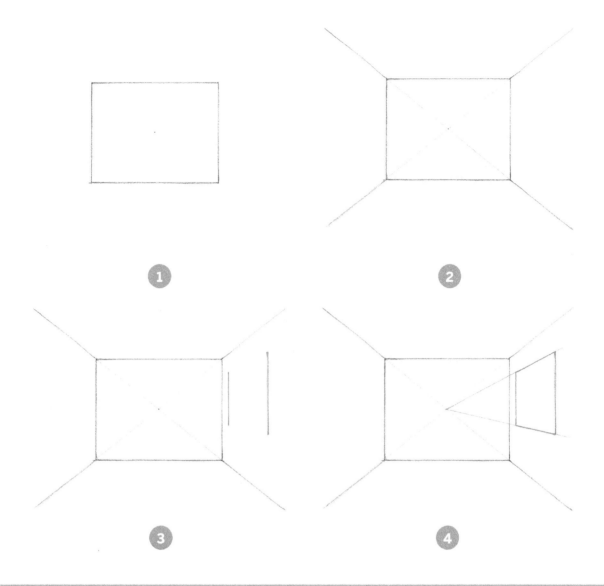

1

2

3

4

BONUS CHALLENGE

Add a rug, furniture, and decorations to your interior room. In my drawing here, I added a table with a vase. Be creative. You can add curtains, another window, or a painting. When you're done, you can erase your guidelines.

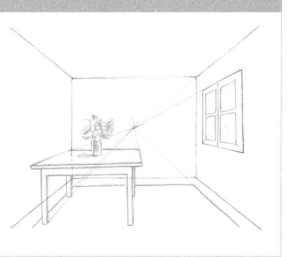

Exercise 4: A City in Two-Point Perspective

Now that you're learning to draw with perspective, you'll see the whole world differently. In this exercise, we'll draw a city scene. From now on, you may see a city through an artist's eyes!

DURATION: 30 minutes

GETTING STARTED: Find a ruler or straight edge to guide you.

Steps

1. Draw a horizon line across the paper with one vanishing point on either side.

2. Draw a vertical line starting close to the center of the horizon line that extends close to the bottom edge of the page. This will be the edge of the building closest to you.

3. Draw diagonal lines that connect the endpoints of the vertical line to both vanishing points.

4. Draw two more vertical lines to show the back edges of the building.

5. Connect the top corners to opposite vanishing points. This forms the top of the building. Erase the extra guidelines.

6. Add more buildings of varying heights using the same steps.

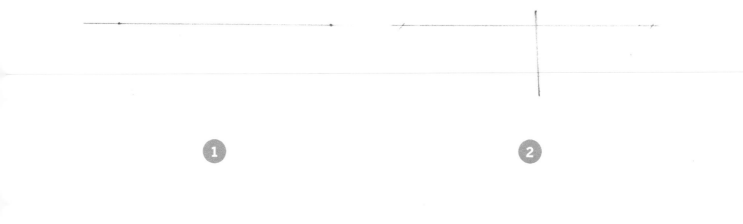

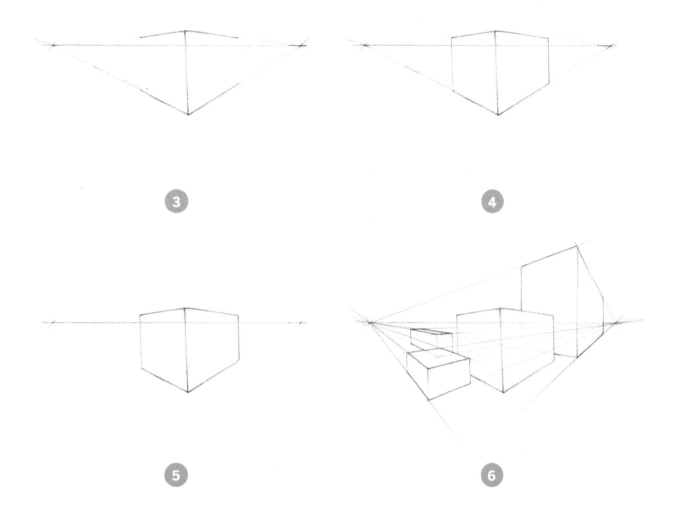

Draw doors and windows that also recede to the vanishing points to make your buildings look more realistic! When you're done, erase the guidelines.

CHAPTER 6

Shading and Light

Adding a range of value to your drawings helps them become more realistic. **Value** is how light or dark an area is in your drawing. When you practice shading, you are incorporating shadows. When you incorporate lighter values, you are referencing the highlights. **Shadows** are the areas that are not receiving light. **Highlights** are the areas directly receiving the most light.

In this chapter, you will create a value scale. This is an excellent exercise for you to learn how to capture distinct changes in shading. Without value, your drawings are going to look more like coloring book pages because they only consist of an outline. Adding value will make your drawings look more realistic and represent the highlights and shadows found on your subject matter.

Think back to the three-dimensional forms you learned to draw in chapter 3. If you add a full range of value to these drawings, you can really make them come alive.

There are a number of ways to add value and show light in a drawing. In this chapter, you are going to practice shading, hatching, and crosshatching. **Hatching** is a way of showing changes in value with linear marks, or hatches. The closer together the hatches are, the darker the value. **Crosshatching** is similar to hatching, but the hatch marks crisscross on top of one another.

As you work through these exercises, pay attention to how these three basic techniques bring form, dimension, and perspective to your work. You'll be surprised at how lifelike your sketches will begin to look!

Exercise 1: Shading Value Scale

If you are drawing in a sketchbook, flag this page. Your value scale will be helpful in exercise 2. Creating a **value scale** will help you practice shading and notice distinct differences in light and dark. When you complete a drawing, check it over with your value scale and see if you have a variety of light and dark values. If your drawing is just one or two values, it's going to feel flat and unrealistic.

DURATION: 10 minutes

GETTING STARTED: Draw a row of five boxes and number them. This will be a scale from light to dark.

Steps

1. Use your pencil to shade box 5 so that it is as dark as you can get it.

2. As you move from right to left, the boxes will become lighter. Shade box 4 so that it is less dark than box 5. Try not to think too much about all the boxes as you shade; just focus on the box you are currently working on, and try to make it only slightly lighter than the one to its right.

3. Shade the rest of the boxes to complete the value scale. Box 3 will be medium gray. Box 2 will be light gray. Box 1 will be white, and you will not shade it at all. While this may seem like an easy exercise, creating distinct values is a skill that takes practice. Apply more or less pressure with your pencil, and experiment with different pencils.

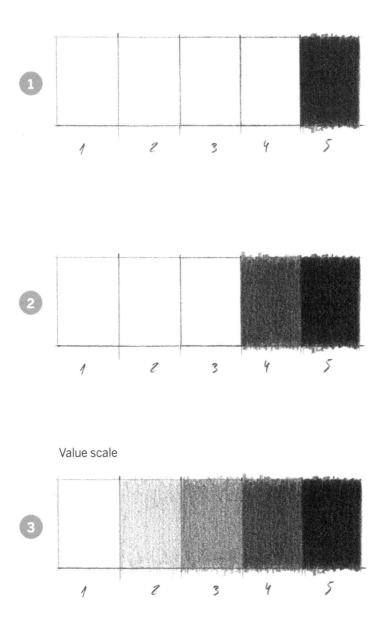

1 1 2 3 4 5

2 1 2 3 4 5

Value scale

3 1 2 3 4 5

Exercise 2: Shading a Sphere

Have your value scale handy, as you will refer to it as you begin shading your sphere. If you need a refresher on drawing a sphere, refer to chapter 3, exercise 3 on page 18.

DURATION: 15 minutes

GETTING STARTED: Set up a ball and a lamp, if you have them handy.

Steps

1. Begin by drawing a two-dimensional circle.

2. Imagine that a light source is at the upper left corner of the page. Add a dark gray value on the side of the sphere receiving the least amount of light. If you are using a ball and a lamp, this can be a great way to observe where changes in value happen on your subject. Direct your lamp toward the ball and see where the light hits.

3. As you get closer to the light source, create lighter values. Apply less pressure with your pencil, or switch to a pencil with a harder lead. Remember that when you are shading, you need to make marks that correspond to the curve of the ball.

4. Add a shadow, if you wish.

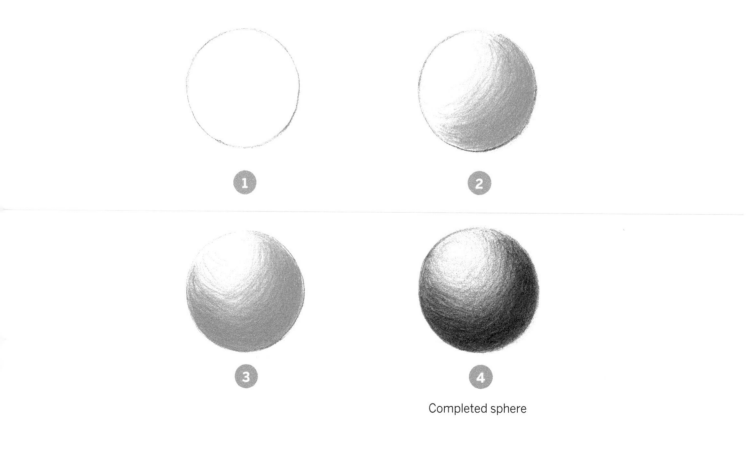

Completed sphere

Exercise 3: Hatching and Crosshatching Value Scale

Just as you referenced your shading value scale, you'll want to keep this scale handy for later exercises, too. As with shading, we have a range of value when we hatch or crosshatch. In this exercise, we'll explore these value scales.

DURATION: 20 minutes

Steps

1. Draw a row of five boxes as we did in exercise 1 of this chapter (see page 50). Label it "Hatching."

2. Create a value scale using hatch marks. The closer together your marks are, the darker the value they create. You do not need to press harder with your pencil or try to make your lines darker. Your eyes will automatically fill in the space between the marks. Hatch marks that are farther apart will read as a lighter value. Try slowing down your pencil and deliberately separating your marks more as you make lighter values.

3. Draw a second row of boxes and label it "Crosshatching."

4. Create a value scale using crosshatching. Crosshatching is very similar to the process you used with hatching, only this time your marks will cross over one another like a checkerboard. Again, the closer the crosshatch marks are to one another, the darker the value. Try creating a scale with hatch marks first, and then go back a second time to cross your previous marks from a different direction. Think of this as a woven basket. With a tighter weave, less light will shine through the basket. With a looser weave, more light will get in.

CONTINUED >

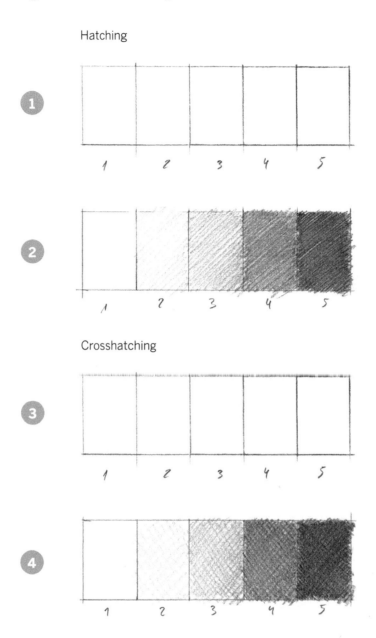

Hatching

Crosshatching

Apply hatching or crosshatching to add value to one of your previous drawings. Identify where the darkest shadows and lightest highlights are. Add this method of creating value to your drawing.

Exercise 4: Draw a Cylinder Using Hatching and Crosshatching

For this exercise, you can use a cylinder you drew in chapter 3, exercise 2 on page 17, or you can draw a new one. If you're ready to start pushing yourself further, feel free to try the exercise with a ballpoint pen.

DURATION: 10 minutes

GETTING STARTED: Set up a cylindrical object, like a can.

OPTIONAL SUPPLY: Ballpoint pen

Steps

1. Use your pencil, or a ballpoint pen, to draw a three-dimensional cylinder.

2. Add each of the five distinct values from your value scale by applying the hatching or crosshatching techniques. If you are looking at a can or another cylindrical object, try to identify where the light and dark areas fall on cylinder.

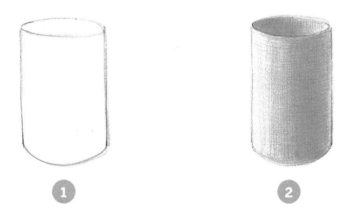

BONUS CHALLENGE

Use this form and technique on a can you draw from observation. Try looking at a soda can and adding the brand design to your drawing.

Exercise 5: Draw an Eye with Shading and Light

Drawing an eye is a great way to practice using a full range of value. By shading different values, you can transform an ordinary drawing into something that looks much more realistic. This is because you are paying attention to the changes in light and how they look in and around the eye.

DURATION: 30 minutes

GETTING STARTED: Before you begin, look in the mirror and observe the different parts of your eye. If you don't have a mirror handy, look up an image for reference.

Steps

1. Draw a football shape as the opening of the eye.

2. Draw two curved lines to show the sides of the iris.

3. Draw a small circle inside the iris to represent the pupil.

4. Draw a curved line above to represent the crease above the top eyelid. This line should be slightly shorter than the curved line below.

5. Draw a shorter line beneath to represent the bottom eyelid. It should stop near the edge of the iris above.

6. Shade the pupil in dark black, and then use your eraser to erase a small highlight or two inside the pupil. If you look at someone's eyes, or at your own in the mirror, you can see specs of light inside the pupil.

7. Shade the iris in medium gray. Shade from the center radiating out to the edges.

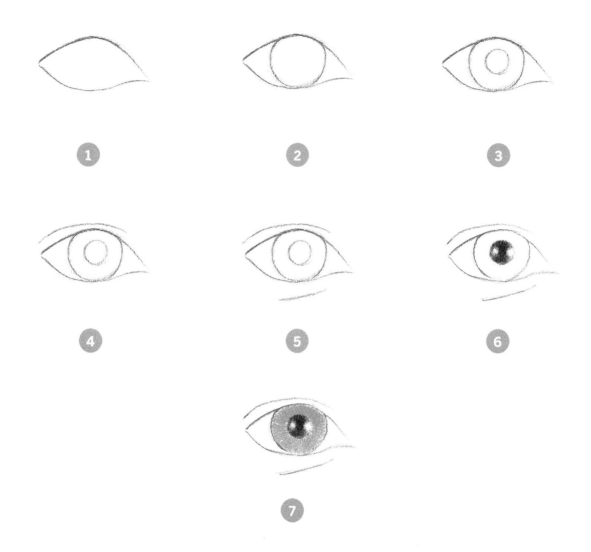

Add detail to the eye. You can create a pair of eyes with eyelashes, eyebrows, and a full range of value. You can add wrinkles underneath the eye, if you'd like.

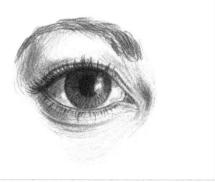

Exercise 6: Draw a Vase Using Hatching and Crosshatching

In this exercise, we'll take a still life to the next level with hatching and crosshatching. I recommend using a vase, but you can use any cylindrical item you like. If you're feeling adventurous, grab a ballpoint pen and try it out!

DURATION: 30 minutes

GETTING STARTED: Set up a vase on a desk or table. Arrange flowers in the vase if you're up for more of a challenge.

Steps

1. Use the skills you learned from drawing a cylinder to help you create the form of a vase. The opening of the vase will be an oval, just as it was for the cylinder. The form of your vase is probably more curved than a straight cylinder. Try to keep both sides of the vase symmetrical to help make it look realistic.

2. Use your pencil, or a ballpoint pen if you're up for a new challenge, to add value to the vase with hatching and crosshatching. You can use a lamp to direct light onto your subject if it helps you identify highlights and shadows.

3. Draw flowers inside the vase and apply a range of value to the drawing. Use your value scale to help make sure you have a variety of light and dark.

4. Complete the drawing by adding an environment with a surface underneath the vase and a background behind it.

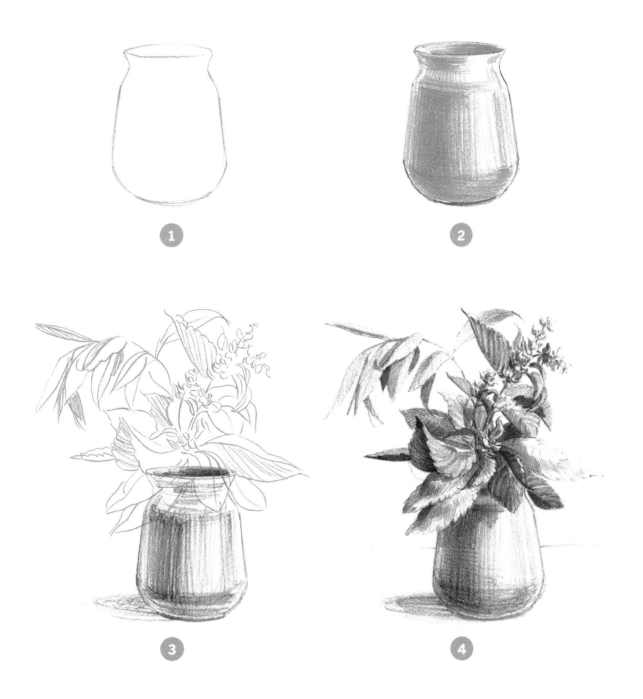

CHAPTER 7
Texture and Detail

Throughout this book, you have developed skills to elevate your drawings from basic sketches to more realistic and three-dimensional compositions. Texture and details are those finishing touches that add interest to your drawings.

Texture is how an object feels or appears to feel. You can experience actual texture when you touch the rough surface of tree bark. When you re-create the appearance of tree bark in a drawing, you are creating an **implied texture**.

Adding details to your drawing requires close observation. For example, if you draw an apple, you already know to draw the contour edges and shade the form. However, you can add details by paying close attention to bruises or spots on the apple.

Exercise 1: Actual vs. Implied Texture

This simple exercise will train you to see texture the way an artist does.

DURATION: 10 minutes

GETTING STARTED: Find an object in your home that has a visibly rough texture. For this exercise, I am using the bottom of a shoe.

Steps

1. Press the shoe into a piece of paper, then lightly shade over the area to reveal the shoe's texture. Look at the shapes, patterns, and details on the paper. This represents the object's *actual texture*.

2. Use this imprint to try to re-create that same texture by drawing it. This is called creating an implied texture. You are helping the viewer imagine what the surface might feel like. Draw some of the repeated patterns you see from the imprint. Remember to focus on basic shapes first, before obsessing over any details. The intention of this exercise is to begin seeing and drawing textures.

Actual texture Implied Texture

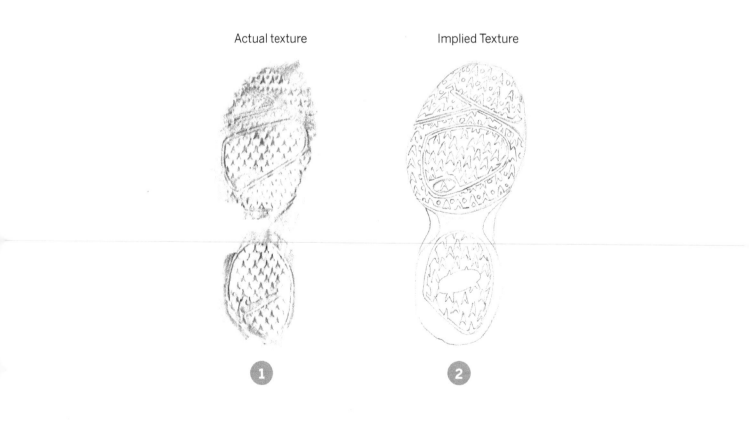

1 2

Exercise 2: Soft Texture

Choose an object with a soft texture: a pillow, a stuffed animal, etc. I am using a pillow for this exercise.

DURATION: 20 minutes

Steps

1. Draw the contours of the object from observation. If you need a refresher on contour lines, that's okay! Refer to chapter 2, exercises 1 to 3, starting on page 6.

2. To create an implied soft texture, you're going to use more curved lines, rounded shapes, and light values. By combining these elements, you're communicating to the viewer what the surface might feel like.

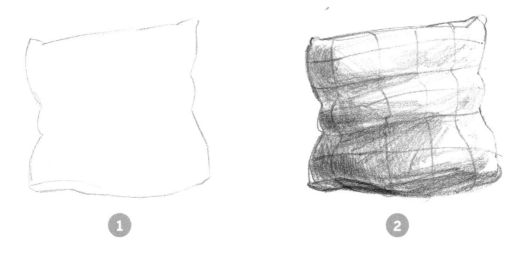

BONUS CHALLENGE

Use the skills you learned for depicting soft texture to practice drawing clouds, cotton candy, or sheep's wool. Remember to focus on the lines to capture the shape first, then focus on the details second.

Exercise 3: Rough Texture

Take a look outside your home or building for an example of rough texture such as brick, siding, plaster, etc. For this exercise, I am using a brick wall, but you can use anything you like.

DURATION: 20 minutes

Steps

1. Observe a section of your home or building up close and try to re-create that texture on the paper. Sketch out the shape of the brick, stone, or other building material. This may consist of square, rectangular, or irregular shapes.

2. Feel the surface with your hand. Look closely at the material to see how edges or grooves affect how the surface feels. To create a rough texture, you're going to use more straight or jagged lines, and dots to represent any bumps.

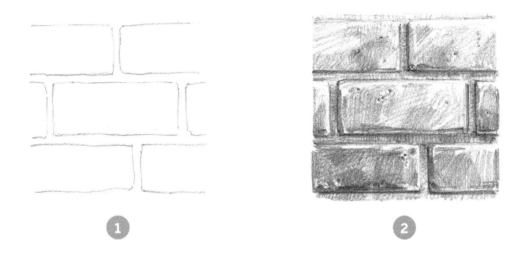

BONUS CHALLENGE

Now try drawing a whole house or building and applying different textures. You can use some of your previous sketches and build upon them, or you can test yourself and start a new drawing from scratch!

Exercise 4: Details with Pattern

Find a piece of clothing with a pattern. For this exercise, I am using a flannel shirt. You can also use a curtain or some other piece of fabric.

DURATION: 20 minutes

GETTING STARTED: Hang the clothing or object up in a well-lit area, somewhere you can easily look at it.

Steps

1. Begin by drawing the contour lines.

2. Before you add the pattern, observe that the pattern isn't perfectly flat, but changes with the folds. You can see the folds by the curved and wavy lines they create. You'll also notice this by the changes in value, or light. Shadows are going to appear where there is less light hitting the fabric. Indicate these by shading areas on the drawing. With this in mind, add any patterns with lines and shapes that you observe on the fabric.

3. Look for additional details like stitching, buttons, zippers, etc. Each of these details can be broken down into basic shapes or lines. Buttons are most likely circular in shape. Stitching and zippers can be re-created by a series of lines.

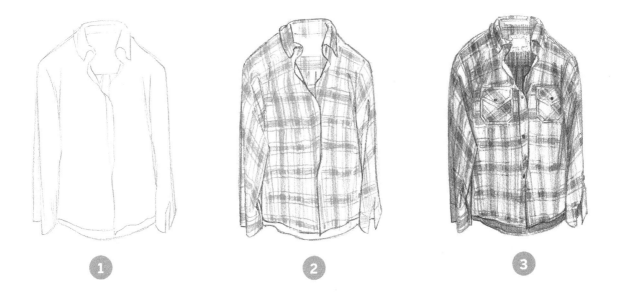

BONUS CHALLENGE

Draw your living room and some of the patterns you see: curtains, upholstery, rugs, etc.

Exercise 5: Draw Details from Nature

Drawing a tree can be difficult for beginners. Focus on drawing the trunk and just a few limbs, so that you can practice applying texture.

DURATION: 30 minutes

GETTING STARTED: Go outside and find a tree that is in an area where you can sketch comfortably. For example, look for a tree near a bench that is well lit. For some, it may help to consider the noise level, too.

Steps

1. Take a close look at the tree trunk. Draw any knots or holes in the tree. Look for shapes. Knots are going to have circles or ovals that you can sketch in. Add curved lines around the shapes to indicate where the tree bark is surrounding the knot. Focus on a few main details that stand out to you at first glance, and then come back later to add any others.

2. Use jagged and wavy lines to re-create the texture of tree bark.

3. Begin drawing some of the leaves of the tree. For this exercise, you're creating the suggestion of a few leaves. Don't get caught up with trying to draw every single leaf. Create an outline shape where the leaves are located and then highlight a few throughout the drawing.

4. Look for other details on and around the tree: roots, grass, birdhouses, mulch, dirt, etc. Draw them in to your liking.

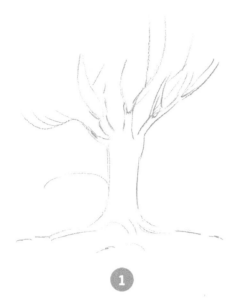

1

2

3

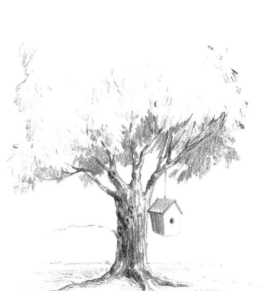

4

Exercise 6: Draw a Self-Portrait

If you still have your sketch of the portrait from chapter 4, exercise 3 (page 30), it's best to use that for this exercise. You'll need it for reference. If you don't have it, you may want to create a new portrait and return to this exercise when you are ready. For the purpose of this exercise, you will want a generic face.

DURATION: 30 minutes when building on a previous drawing (allow extra time if starting from scratch)

GETTING STARTED: You'll need a mirror and bright lighting for this exercise.

Steps

1. If you no longer have your drawing from chapter 4, exercise 3, return to that exercise to create a new portrait.

2. Take a look in the mirror to create a self-portrait as unique as you are. Use a mirror in a well-lit area where you can comfortably sit and draw. Although working from a photograph would be okay, it's best to learn by drawing from life. Look straight ahead so that you can apply what you've learned about proportion and symmetry. Start by adding the contours of your hair. Focus on the lines and the shape of your hair rather than the texture.

3. Shade the hair in using your pencil in the direction your hair grows or is parted. Focus on capturing texture and dimension using shading. Look for changes in value as you work.

4. Add distinguishing characteristics: birthmarks, piercings, scars, etc. To add facial hair, repeat a series of hatch marks to indicate which way the hair is growing.

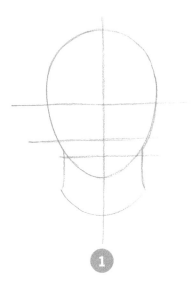

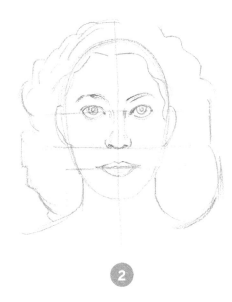

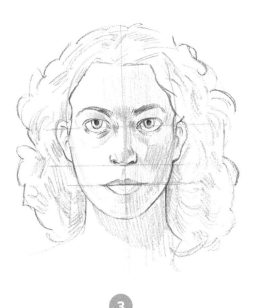

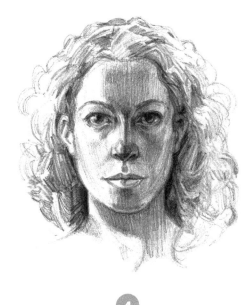

CLOSING WORDS

Drawing is a form of expression, but it takes some time to learn a few techniques and rules. Hopefully these exercises have provided you with the tools you need to draw more independently. As with any new skill, you need to practice. Drawing requires that you not only practice with pencil and paper, but also practice how you observe your subject. The more time you spend looking at objects, figures, and landscapes, the easier it will be to identify shapes and how they fit into space. Your drawing will continue to improve over time. Be sure to find subject matter that you are interested in to help keep you engaged. You will be more invested if you are excited about the subject. Look for inspiration in your daily life, your environment, and your relationships. You have developed new skills throughout this book that you can apply to new drawings that are unique to you. Have fun and keep drawing!

GLOSSARY

Asymmetry: lack of symmetry, or difference on two sides of an axis

Atmospheric perspective: how the viewer sees objects as they recede into the distance

Background: the area of the picture that is farthest from the viewer

Composition: how the elements of a drawing are arranged and fill space

Contour line: an outline that defines the edges of a shape

Crosshatching: method of hatching in which the hatch marks crisscross

Depth: the distance from the foreground to the background in a drawing

Figure: typically refers to the human body as the subject of artwork

Foreground: the area of the picture that is closest to the viewer

Form: a three-dimensional figure

Gesture drawing: quick sketch of a figure

Guidelines: temporary lines to help measure symmetry, proportion, and perspective

Hatching: technique for showing changes in value with linear marks, or hatches

Highlights: areas in a drawing that receive the most light

Horizon line: an imaginary line that designates where the sky and ground meet

Implied texture: texture that is drawn or painted to look like something it is not

Middle ground: the area of the picture that is between the foreground and background

Negative space: space that is not occupied by the subject matter

One-Point perspective: objects receding in space to one vanishing point

Perspective: technique for making images appear three-dimensional on a two-dimensional surface

Positive space: space that is taken up by the subject matter

Proportion: how one part relates to the whole or how each part compares to others in size

Range of value: a variety of shades from light to dark

Shadows: areas in a drawing that do not receive light

Shape: a two-dimensional enclosed line

Sketching: loose and quick drawing to lay the foundation for added details and refinement

Still life: an arranged group of inanimate objects

Subject: the focus of an artwork

Symmetry: the property of being the same on both sides of an axis

Texture: how an object feels or appears to feel

Two-Point perspective: objects receding in space to two vanishing points

Value: how light or dark an area of a drawing is

Value scale: a visual representation of changes in value from light to dark

Vanishing point: the point where objects increasingly become smaller until they disappear to create the illusion of depth

ABOUT THE AUTHOR

Jordan DeWilde is an art educator from Illinois. After graduating with a BS in broadcasting and double major in art from Western Illinois University, Jordan went on to earn his MS in art education from Illinois State University. Jordan has taught art for over nine years in K–12 public schools. Jordan was awarded the Illinois Elementary Art Educator of the Year award in 2018. In addition to teaching, he shares curriculum ideas on social media with art educators from all over the world. He writes regularly for *The Art of Education University Magazine* on topics pertaining to contemporary art, social justice, and art education.

Outside of school, Jordan finds inspiration from traveling and exploring art and culture in new places. He incorporates these experiences into his curriculum and shares a passion for art with his students. Jordan strives to create an inclusive curriculum by developing lessons with positive representation of diverse artists and issues. He tells his students, "Great art has been created by men and women of different races, cultures, and communities throughout history." His mission is to teach his students that art is for everyone. You can follow Jordan DeWilde on Facebook, Twitter, and Instagram: @mrdewildeart.